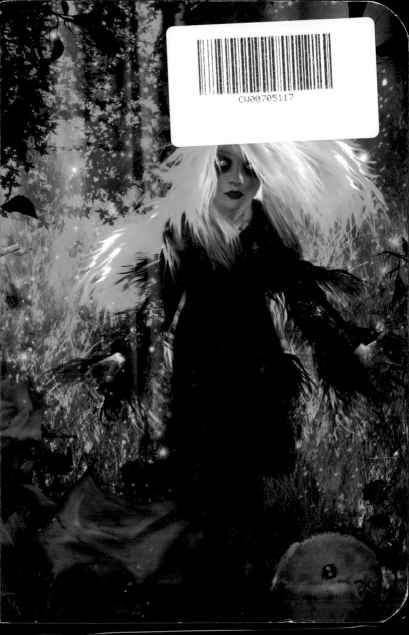

MYKE AMEND WILD ROSE
Adobe Photoshop
www.mykeamend.com

An immortal beauty moves through the night flowers in Amend's *Wild Rose*. "By the light of the moon she appears, forever waiting for the handsome boy who led her to this clearing by the stream. Death, to her, is a stranger—she does not know of her own passing; she does not understand the harm caused by her embrace; she does not remember exactly what he looked like... she only wonders, 'where have you been?'"

From *Vampires: 30 Postcards* / Published by Ilex Press © 2012

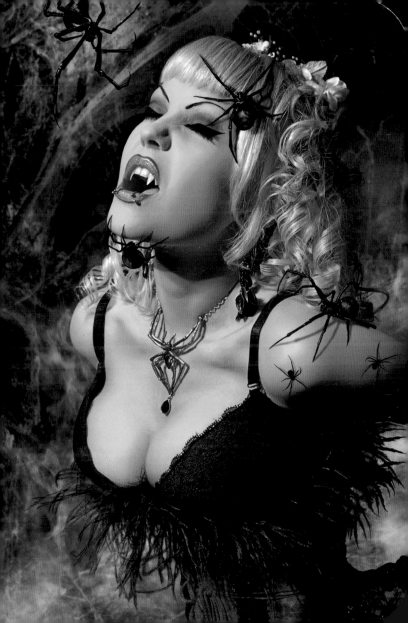

MICHAEL PARK THE WIDOW
Photography and Digital art
Model: Saint Deviless
www.darkartdesigns.com

"Kayla, a.k.a. KLOSTER, was turned into a vampire against her will by her mother, Arachne, an immortal half-woman half-spider. Arachne was so in love with her daughter, she could not bear to see Kayla grow old and die. Kayla's lover Maliki helped her escape the clutches of her mother, but in only a few months Kayla's blood lust became too strong and she killed Maliki. Wanting revenge for being an immortal savage, she killed her mother and absorbed the power to control all spiders and could even shift into a large spider or many small spiders."

From *Vampires: 30 Postcards* / Published by Ilex Press © 2012

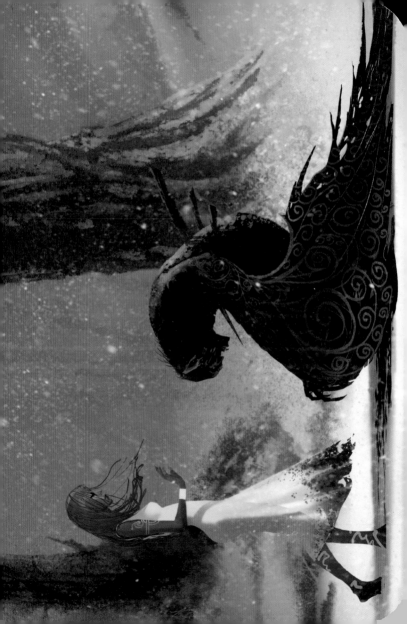

ARMAND BALTAZAR DEATH OF THE KING
Pen, ink wash, and digital finishing
www.armandbaltazar.com

A tragic defeat? A touching and cold image with a dying beast hunched over in blood; it is impossible not to notice the still elegance of this image. The snow is covered in blood and although the foul demon may have deserved his death, it is difficult not to feel a sense of pity. Baltazar describes the context: "The painting depicts the last moments of the dying Vampire King who stands before his human daughter, who has slain him."

From *Vampires: 30 Postcards* / Published by Ilex Press © 2012

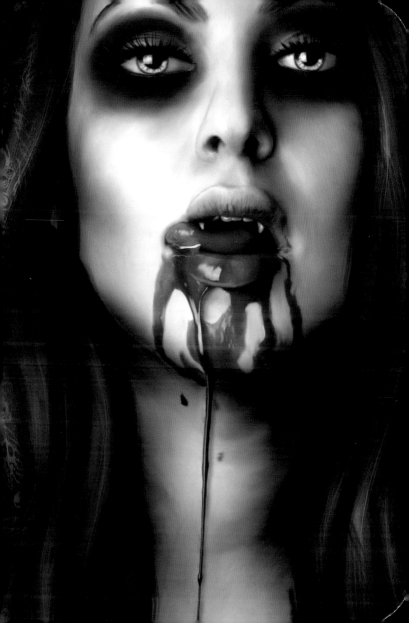

JOANA DIAS SUNSET
Adobe Photoshop
www.shinobinaku.net

The character Sunset reveals a bloodthirsty appetite as scarlet rivers of blood drip down her lips, contrasting against her pale skin. Gore-loving nymphs always make the most heinous acts look sensual. Dias says: "I wanted to create a portrait of Sunset, as she is a centerpiece in my cast of original characters. In order to create her more faithfully to my vision, I drew her from scratch, unlike the majority of my work, which is photomanipulation."

From Vampires: 30 Postcards / Published by Ilex Press © 2012

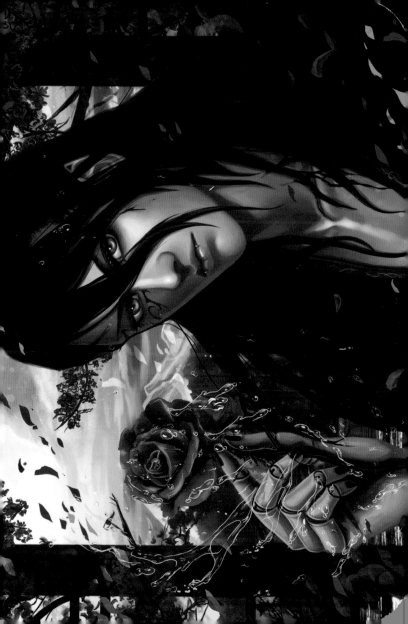

LEAH KEELER BLOOD ROSES
Adobe Photoshop
http://keelerleah.deviantart.com

In the midst of falling leaves, a gorgeous bloom is held by a long-haired dandy in Keeler's *Blood Roses*. "An attractive male vampire holding a rose; is he attempting to lure you in or is he offering you the rose? This is a slightly altered version of a painting I did for an online ball-jointed doll contest, hence the jointed hand. I was really pleased with the outcome and I had a great response to the finished work."

From *Vampires: 30 Postcards* / Published by Ilex Press © 2012

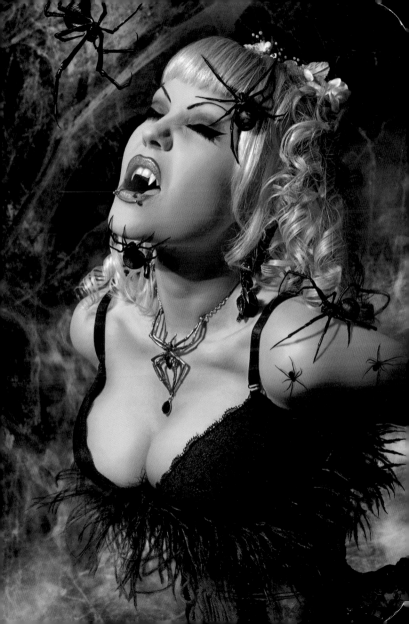

MICHAEL PARK THE WIDOW
Photography and Digital art
Model: Saint Deviless
www.darkartdesigns.com

"Kayla, a.k.a. KLOSTER, was turned into a vampire against her will by her mother, Arachne, an immortal half-woman
half-spider. Arachne was so in love with her daughter, she could not bear to see Kayla grow old and die. Kayla's lover
Maliki helped her escape the clutches of her mother, but in only a few months Kayla's blood lust became too strong
and she killed Maliki. Wanting revenge for being an immortal savage, she killed her mother and absorbed the power to
control all spiders and could even shift into a large spider or many small spiders."

From *Vampires: 30 Postcards* / Published by Ilex Press © 2012

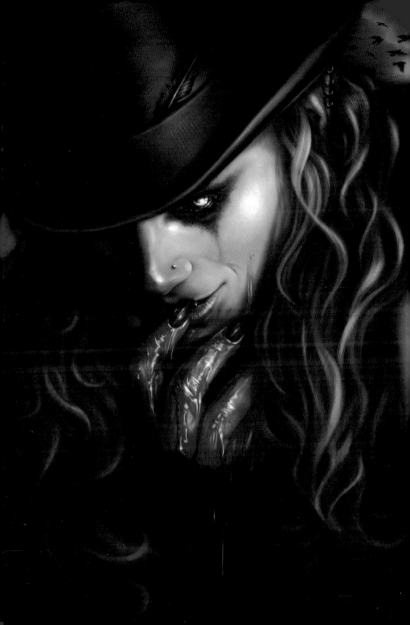

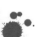

CHRISTINE M. GRIFFIN BEAST
Adobe Photoshop
http://christinegriffin.artworkfolio.com

It isn't quite clear if this horrid thing is bringing a finger to his lips in thought or in thirst! "Sometimes it's just fun to wallow in the expected: a top hat, lots of blood, a flock of crows, ravens, and blackbirds, demonic eyes. But what you get is greater than the sum of the parts. The blood was particularly tricky. I started using Bevel and Emboss in Photoshop, then just painted over the whole mess. I looked at many grisly photos to get the glop just right. Good thing I'm not squeamish."

From *Vampires: 30 Postcards* / Published by Ilex Press © 2012

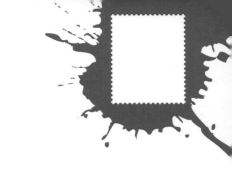

MICHAEL PARK DIE NÄCHTLICHE
Digital photography
www.darkartdesigns.com

An alluring femme fatale stands in the shadow of an ancient castle in Park's *Die Nächtliche* (English translation: *The Nocturnal*). "Vampire Duriel is depicted in this scene; she is a newly born vampire made from one of the most sacred and ancient clans, the clan which Lilith started somewhere around 700 BCE. She was turned to provide her master with fresh victims in his mansion in the sky. The mansion was built high upon a steep mountain and the only way to get to it is by flight. Human victims cannot resist her exquisite beauty... she is truly to die for."

From *Vampires: 30 Postcards* / Published by Ilex Press © 2012

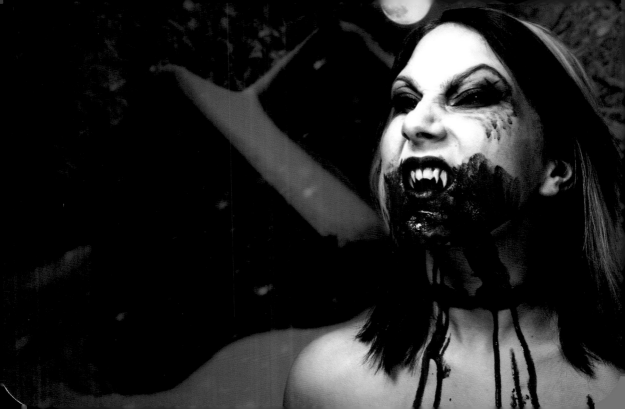

MICHAEL PARK THE VAMPIRE SKADI
Digital photography
www.darkartdesigns.com

A deliciously gruesome image from Park. "No one really knows how old Skadi truly is; she woke about a hundred years
ago with no recollection of her past. She is called Skadi because that is what was etched on her tomb. She can control
the weather, which comes in handy when she wishes to go out during the daytime. She is savage and her thirst is
boundless; she is extremely dangerous and no one comes out of the Norwegian forests alive."

From *Vampires: 30 Postcards* / Published by Ilex Press © 2012

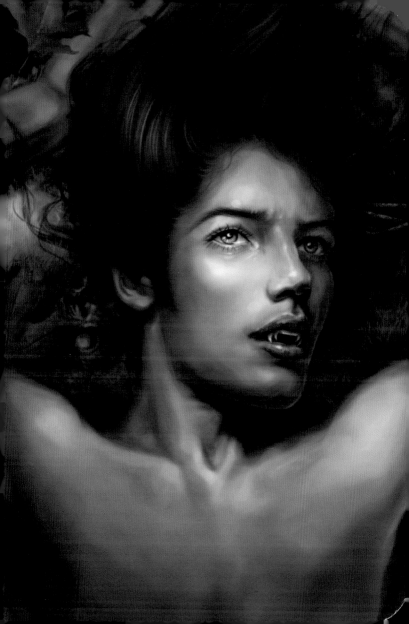

CHRISTINE M. GRIFFIN MY VAMPIRE EYES
Adobe Photoshop
www.christinegriffin.artworkfolio.com

This romantic, ethereal portrait offers a softer representation of the traditional vampire. Griffin shares her technique for
My Vampire Eyes: "Pale skin can be tricky. It's easy to want to simply add white to everything, but that can either turn
bland and chalky or, with digital media, look overexposed. The key is to keep color in there; in this case, very subtle
greens and pinks. Green with red is my favorite complementary pairing. I added cool pink to my highlights and a warm
green to my shadows. It's all about hidden opposites!"

From *Vampires: 30 Postcards* / Published by Ilex Press © 2012

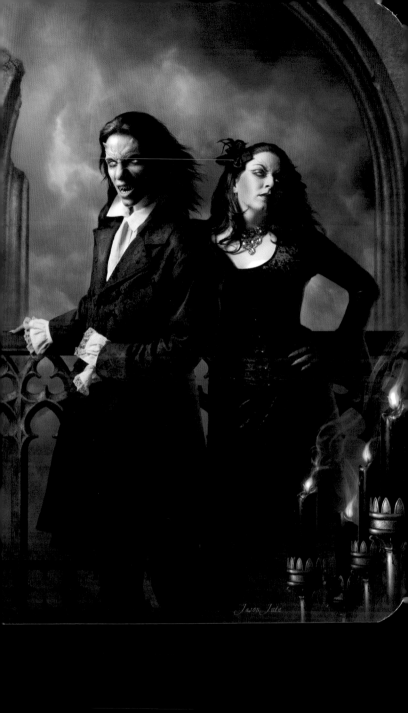

JASON JUTA VAMPIRIC NOBILITY
Digital Photography and Adobe Photoshop
www.jasonjuta.com

A growling male beast and his female counterpart stand proudly in this scene complete with gothic imagery. The candles glow a supernatural blue color, casting light on this monstrous couple. Juta describes his digital technique: "A Lord and Lady of the undead, photographed in my studio. I processed the image extensively in Photoshop, creating the background and foreground props from personal photography and painted elements."

From *Vampires: 30 Postcards* / Published by Ilex Press © 2012

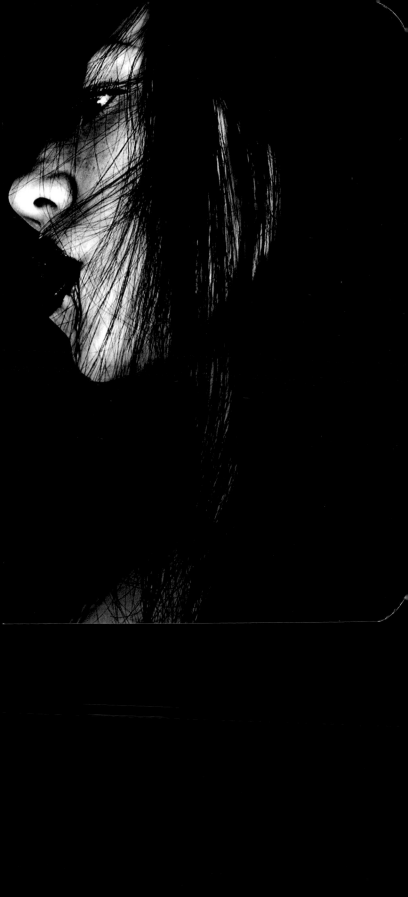

LESLIE ANN O'DELL SINFUL
Photography and Adobe Photoshop
www.shyble.com

This godless creature is rethinking her very nature in this morose piece by O'Dell. The black and white palette portrays
a sort of dual nature, as is a common theme with vampires. The piece was created using a combination of photography
and heavy textures in Photoshop. O'Dell describes the image as, "a portrait of a sensitive female vampire caught in the
moment, thinking of her latest victim. She is questioning what she has become."

From *Vampires: 30 Postcards* / Published by Ilex Press © 2012

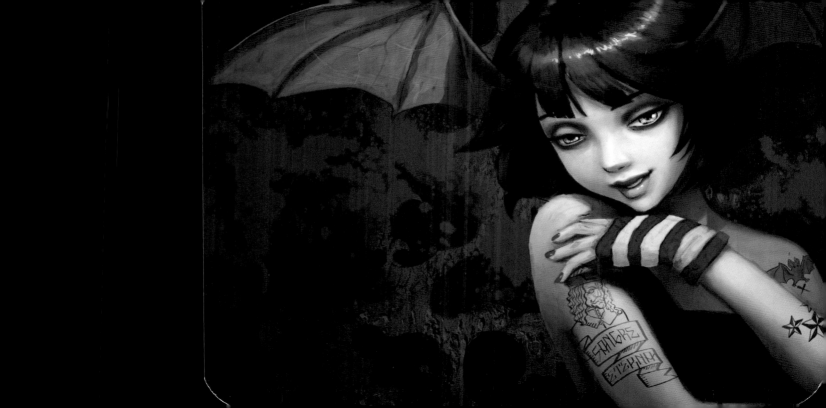

DESEO RRRR
Pencil and Adobe Photoshop
www.deseoworks.com

Deseo's digital piece features a lovely tattooed undead girl with bat wings. "I wanted to take a more anime approach to
the vampire idea. But because I'm also a pop-culture fan, I thought it'd be fun to mix in a bit of tattoo art. The direction
of the wings, arms, and use of light all lead to the eyes and smile of this beautiful, but merciless predator. I drew the
face using mechanical pencil on paper, scanned it, and rendered the rest digitally."

From Vampires: 30 Postcards / Published by Ilex Press © 2012

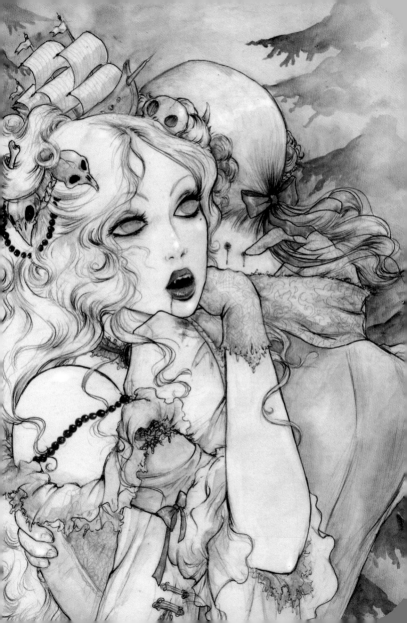

GINA WETZEL OUR LAST EMBRACEMENT
Watercolor with digital highlights
www.tanuki.de.vu

An immortal and her prey entwine in this delicate watercolor piece with digital highlights. "I am very passionate about the Rococo era and its beautiful fashion. Oodles of lace and ruffles and colossal hairstyles—that's just my thing. This opulent and morbid age is the perfect setting for vampire stories. And I also love the sixties, so I thought of the young Brigitte Bardot while drawing the girl's face. Usually I prefer the nostalgic look of completely hand-painted pictures, but in this piece I added some Photoshop highlights to bring out the vampire maiden's porcelain skin."

From Vampires: 30 Postcards / Published by Ilex Press © 2012

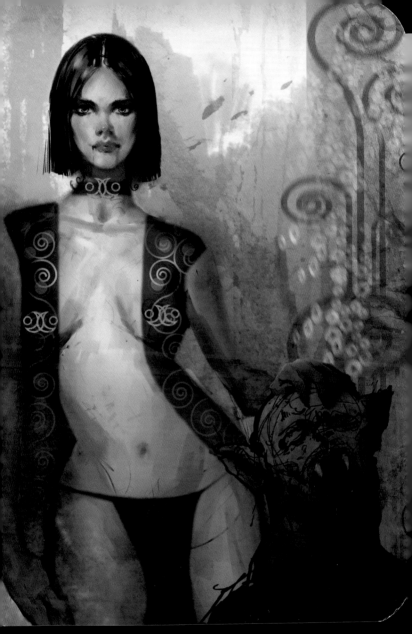

ARMAND BALTAZAR SEINE
Pen, ink wash, and digital finishing
www.armandbaltazar.com

A dark image full of multilayered imagery showcases a cool, calm, collected (and half-dressed) pixie with a demonesque
monster in the palm of her hand. His contorted face is unpleasant and horrid. This painting was created using pen and
an ink wash, and finished off digitally. Baltazar sheds light on his inspiration for the image: "This piece was inspired by
the painting of Gustav Klimt titled *Judith*. It is a dark homage!"

From *Vampires: 30 Postcards* / Published by Ilex Press © 2012

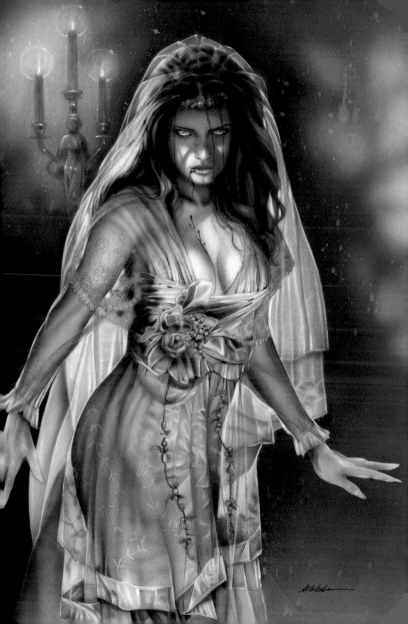

MICHAEL CALANDRA BLOOFER LADY
Airbrush, acrylic, and colored pencil
www.calandrastudio.com

Always a creepy effect, we see a spooky bride dressed in white—but what's this? She has fangs and claws, but still retains all of her feminine wiles, a very dangerous combination! Calandra created this haunting image as a homage. "*Bloofer Lady* is a tribute to Lucy Westenra from Bram Stoker's *Dracula* novel. The character has always been a source of horror and inspiration to me; I specialize in gothic horror depicting beautiful women."

From *Vampires: 30 Postcards* / Published by Ilex Press © 2012

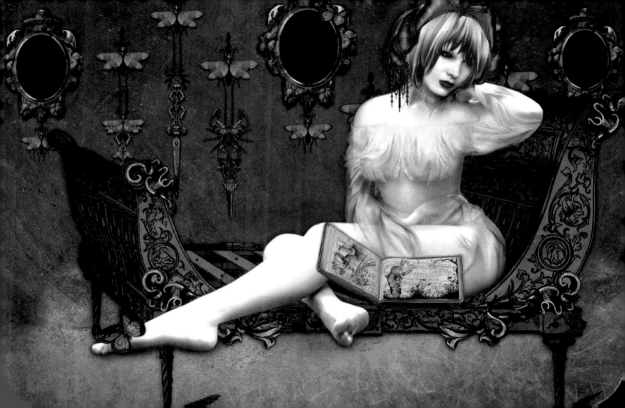

BETHALYNNE BAJEMA THE LOUNGE
Digital painting
www.bethalynnebajema.com

A pink-haired spook enjoys solitude and reflection while casually looking at sheet music in this digital painting by Bajema. "*The Lounge* is a full illustration for the story featuring the character Bex. This artwork was also used in my *Sepia Stains Tarot Deck* for the Magician card. This image is one of the few pieces that I did through digital painting, with the exception of the insects on the wall. Those are from my mechanical insect illustrations."

From *Vampires: 30 Postcards* / Published by Ilex Press © 2012

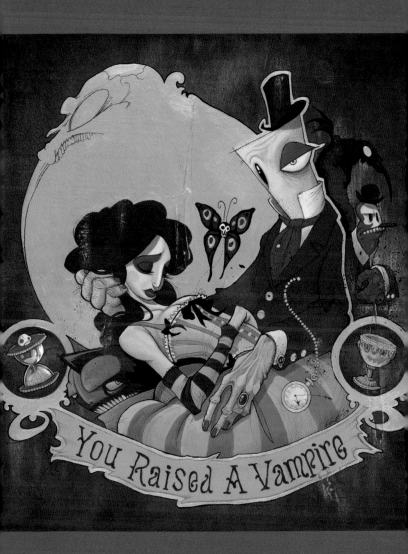

You Raised A Vampire

GRIS GRIMLY YOU RAISED A VAMPIRE
Album artwork for the 7" single You Raised A Vampire *by The Moog*
Acrylic
www.madcreator.com

Not to be dismissed as just a comic piece, *You Raised a Vampire* by Grimly contains a number of deeper implied meanings. The pocketwatch rests prominently in the front of the image with the minute hand extending way beyond the face of the watch in an odd fashion, implying time does not function normally in this world. On both sides of the sleeping girl, in perfect balance, there is a chalice and an hourglass, suggesting there is a limited amount of time before another drink will be needed.

From *Vampires: 30 Postcards* / Published by Ilex Press © 2012

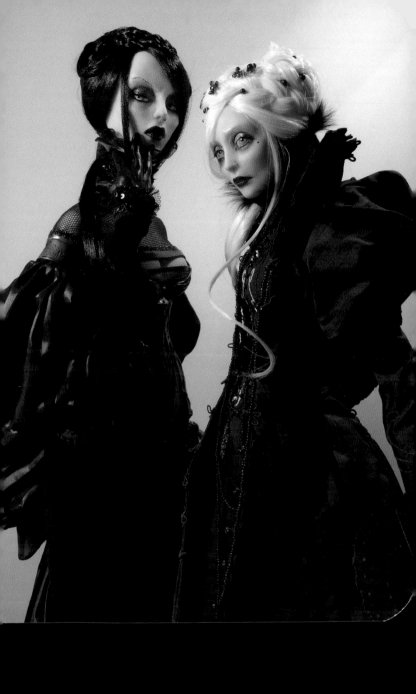

VIRGINIE ROPARS CARMILLA & THE QUEEN OF SPADES
Polymer clay and mixed media
http://vropars.free.fr

A beautifully hand-sculpted duo. "Carmilla (on the left) is inspired by the character in the J. Sheridan Le Fanu novel *Carmilla*. I thought about an adult Carmilla (in the story she is a teen). I'm pretty sure she would have been a terrible vampire fatale. The Queen of Spades is a completely different creation, but those two make a great couple. In contrast, Carmilla seems fragile. The corset of Carmilla is fully sculpted too, and a lot of other materials are used on the pieces, such as different sorts of fabrics."

From *Vampires: 30 Postcards* / Published by Ilex Press © 2012

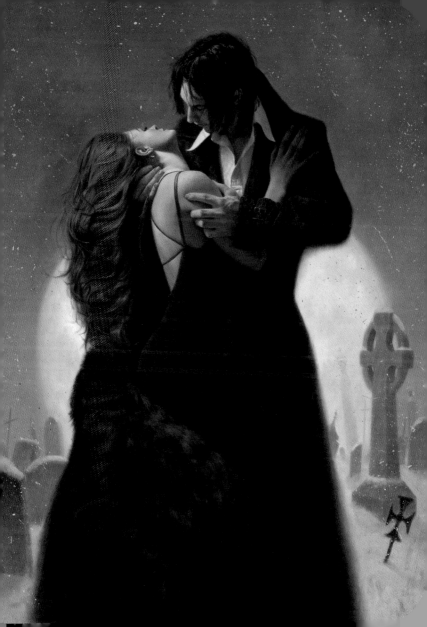

VINCENT NATALE WICKED DEEDS ON A WINTER'S NIGHT
Book cover for the *Immortals After Dark* series
Oil
www.vincenatale.com

Wicked Deeds on a Winter's Night features a woman held in a vampire's embrace. "One of the *Immortals After Dark* series dealing with vampires, werewolves, and witches, and the forbidden love between the characters. The romance is depicted in the clinch, but the danger is conveyed with his hand's position and the direction of his gaze—at her throat. I used cool colors and a higher contrast in this painting to evoke a 'chilly' atmosphere to indicate that all is not warm and fuzzy here."

From *Vampires: 30 Postcards* / Published by Ilex Press © 2012

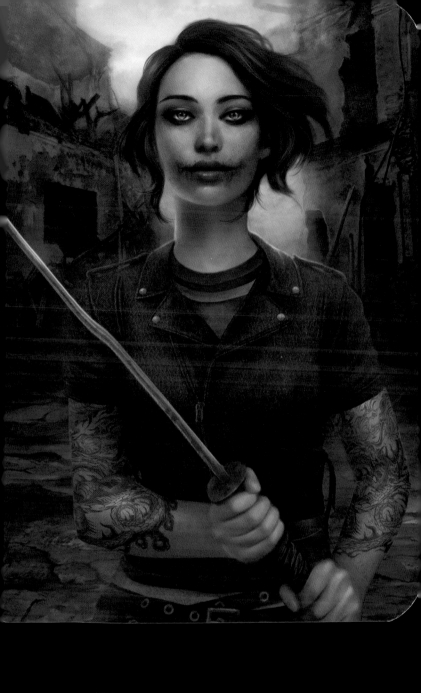

GRACJANA ZIELINSKA URBAN NINJA
Adobe Photoshop
www.vinegaria.com

An armed undead ninja complete with tattoos! "This piece was done originally for my friend Taylor Holloway's 'The Living
Dead' project. I wanted to depict a girl who's a bit insane, not really alive anymore, but not yet dead either. She is also a
bit funny—a tattooed girl running with a katana in the early morning mist through a ruined city? I would enjoy watching
a movie with her, preferably directed by Quentin Tarantino. That surely would be a nice one."

From *Vampires: 30 Postcards* / Published by Ilex Press © 2012

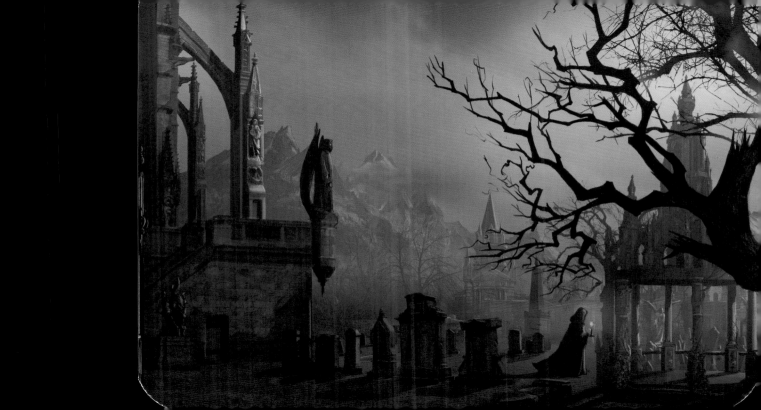

AKIKO CRAWFORD GARDEN OF EVIL
Adobe Photoshop
www.signal2noiz.com

A lone figure carries a candle just outside the castle walls in this digital piece titled *Garden of Evil*. Akiko Crawford explains the background story: "You finally escape out of his castle, but now the garden of evil awaits. Death is in the air, and the lurking warm breeze yearns to tell the stories of the lost souls beneath the earth, yet the garden is strangely beautiful. All you can do now is wait for the sun to rise."

From *Vampires: 30 Postcards* / Published by Ilex Press © 2012

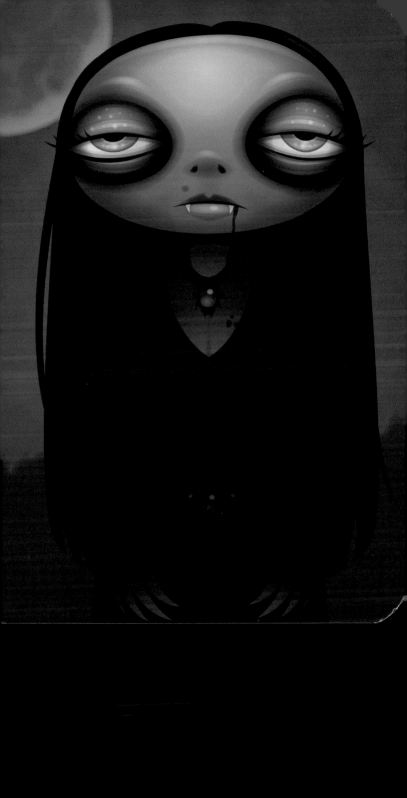

JOHN SCHWEGEL BLOOD RED SKY
Adobe Illustrator
www.johnschwegel.com

This cartoonish ghoul is the creepy creation of Schwegel. "Cute, but creepy vampire girl under a blood-red sky. I wanted to give her a sullen look as though she was getting bored with immortality. This image was created in Adobe Illustrator using the Pen, Pencil, and Shape tools. Highlights and shading were added with various semi-transparent layers. I used some feathering on the moon and background scenery to make them appear out of focus."

From *Vampires: 30 Postcards* / Published by Ilex Press © 2012

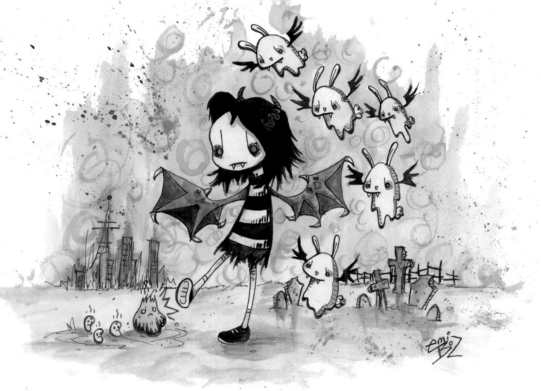

EMI BOZ MELTY VAMPIRE MINIONS HATE GARLIC ARMY
Ink, watercolor, pencil, and acrylic
http://creepalicious-inc.com

"In the land of Snygorlok the melty vampire bunnies lived in fear of the Garlic Army. The Garlic Army hated the melty vampire bunnies for drinking the juice out of their prime minster, Carroting Von Roots, and his entire family. Starved and hungry, the melty vampire bunnies dreaded that the ever-growing Garlic Army would eventually find their secret hideout. That was, until Onkla, the winged vampire girl, found the melty vampire bunnies first. 'Put your war paint on, my melty bunny friends, tonight we take down the Garlic Army!' she exclaimed. That night, the melty vampire bunnies and Onkla met the Garlic Army in gruesome battle."

From *Vampires: 30 Postcards* / Published by Ilex Press © 2012

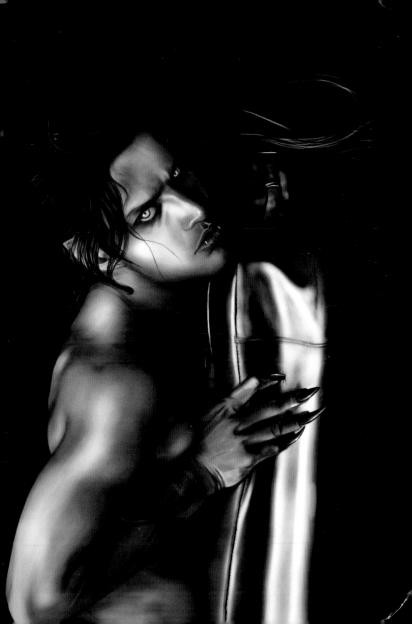

JEANNETTE LANDRAU INCUBUS
Corel Painter
http://mistressj.epilogue.net

Long-haired, handsome, and (as far as the viewer can tell) completely naked! This incubus is every bit as frightening as his vampiric counterparts who are more direct in their method of attack. He still has claws and deadly fangs, the only difference is that his prey are much less able to resist. Landrau describes how she created her piece: "This technique was very simple, after a sketch I used the airbrush and in light layers began to render until completion, using only black."

From *Vampires: 30 Postcards* / Published by Ilex Press © 2012

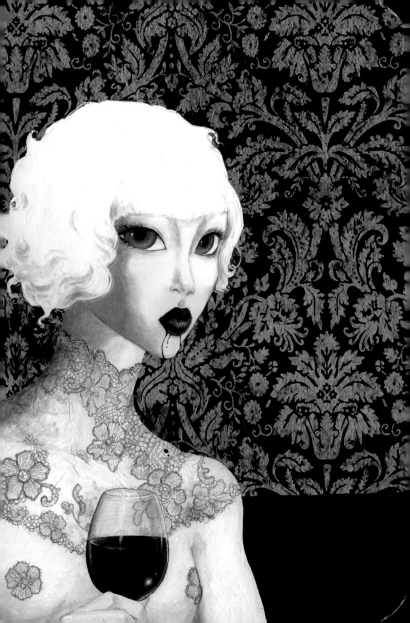

GINA WETZEL WINE
Acrylic and collage
www.tanuki.de.vu

An aristocrat enjoys a glass of curious liquid. "The young duchess with the amber eyes invites you to her castle for a delicious glass of dark wine. But is it really wine? The painting is the left part of a triptych, in which all three pictures show mysterious young ladies with a strange black liquid. I used a collage technique in three layers and various paper grades to give it a more three-dimensional look, and I am very happy with the end result."

From *Vampires: 30 Postcards* / Published by Ilex Press © 2012

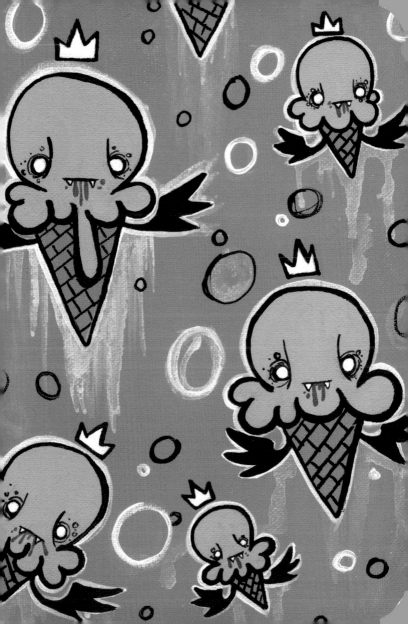

EMI BOZ BLOOD THIRSTY WINGED ICE CREAM
Ink, acrylic, resin, watercolor
http://creepalicious-inc.com

"This is the result when a vampire isn't careful with what they bite. The Vampire Ice Cream Cones seek out their master and make more minion Ice Cream Cone ghouls along the way. The more minions, the more they must feed! Ice Cream Cone flesh no longer does it for the horde, so they've turned to human blood. The only way to put a stop to the Ice Cream Cone Vampires is to set a trap, catch them, and melt them alive; that, or eat them quickly and suffer the worst brain freeze of your pathetic human life!"

From *Vampires: 30 Postcards* / Published by Ilex Press © 2012

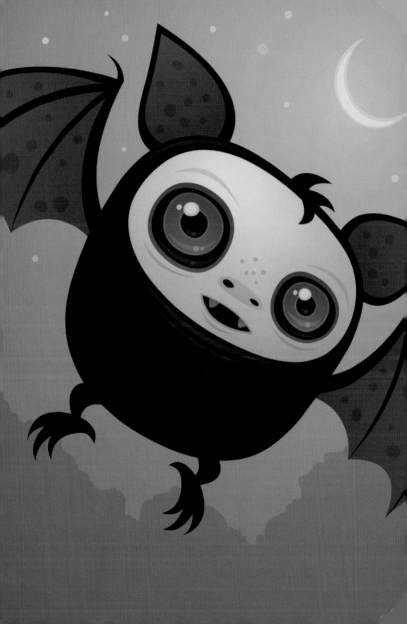

JOHN SCHWEGEL RED EYE
Adobe Illustrator
www.johnschwegel.com

Sometimes it is difficult to tell if we should hug or hide from the undead, as illustrated in this piece by Schwegel. "*Red Eye* was created for Halloween. I just had the urge to draw a really cute little vampire bat boy in a simple style. I chose the red and brown colors to give the image a classic look of an old photo. This image was created in Illustrator using the Pen, Pencil, and Shape tools. Highlights and shading were added with various semi-transparent layers."

From *Vampires: 30 Postcards* / Published by Ilex Press © 2012

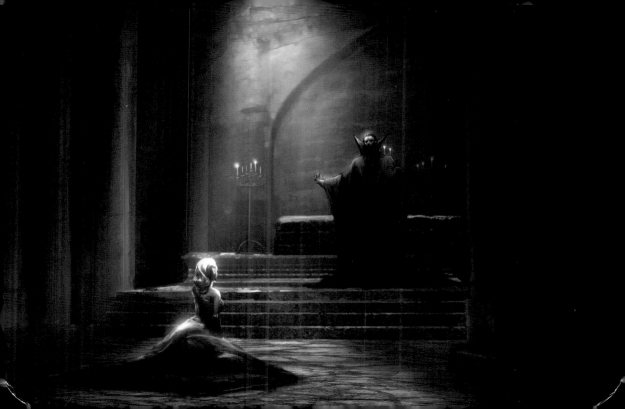

WATCHRIN HANSHIN SACRIFICIAL SANCTUM
Adobe Photoshop
http://watchyh.blogspot.com

An immortal overlord stands tall before a kneeling maiden. "I wanted this painting to have an unholy feeling, but be beautiful in contrast, so I mainly used dark tones for the overall values. I approached the two characters differently by applying the 'light against dark' and 'dark against light' technique to make them stand out from one another. Red was applied to her dress to create a stronger focal point and I gave the vampire a darker shape for a stronger silhouette."

From *Vampires: 30 Postcards* / Published by Ilex Press © 2012

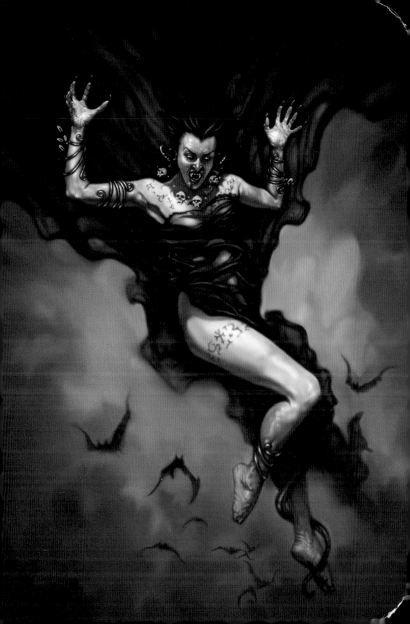

PATRICK JONES IN A GLASS DARKLY
Painted for Carmilla *from* In a Glass Darkly *by J. Sheridan Le Fanu*
Corel Painter
www.pjartworks.com

Bats surround a possessed undead character in this nightmarish piece by Patrick Jones. Is she falling or is she flying?
The lack of any solid ground conveys a sensation of imbalance, but this fang-bearing phantom seems right at home in
the air. Jones has used Painter's Oils and Oil Pastels to great effect. The artist shares some insight: "Painted for the story
Carmilla from J. Sheridan Le Fanu's collected stories, *In a Glass Darkly*. Considered to be the greatest vampire story
ever told, it was also the inspiration for Bram Stoker's *Dracula*."

From *Vampires: 30 Postcards* / Published by Ilex Press © 2012